My Sideways Heart

MONGREL EMPIRE PRESS NORMAN, OK

Cover photo:
Heart Shaped Sky © 2010 by Kyran Daniel John Mish.
Cover design by Mongrel Empire Press.
Text photos:
Art Class Love, Looking at the Cracks &
I'm Burning Your Love Letters © 2010 by Dani Knight.
Flowers with Fingernails & *Heart Feet* © 2010 by Charles Patrick Mish.
Nathan in Santa Fe (bio photo) © 2010 by Ashley Stanberry.

Greek poets' chapter epigraphs from *Acts of Love, Ancient Greek Poetry from Aphrodite's Garden* by George Economou (Modern Library, 2006).

MONGREL EMPIRE PRESS
NORMAN, OKLAHOMA, UNITED STATES OF AMERICA

WWW.MONGRELEMPIREPRESS.COM

This publisher is a proud member of

[clmp]

COUNCIL OF LITERARY MAGAZINES & PRESSES
www.clmp.org

Founding Member
OKLAHOMA
SMALL PRESS
ASSOCIATION

Book Design: Mongrel Empire Press using iWork Pages.

My Sideways Heart

Nathan Brown

Acknowledgements

To Dr. Jeanetta Mish for all the incredible effort you put forth, and all the beautiful books you pull together here at Mongrel Empire Press. This is the work that matters... and you do it so incredibly well.

To Dr. Kyran Mish for all the good cheer, "Misharitas," and the structurally sound support you bring to the party.

To Charlie Mish and Dani Knight—such beautiful work on the photography, such talent. Thank you for being a part of this.

To Sierra, who, hopefully, will not read this book for a couple of decades. Your music, art, and energy inspire me.

To Professor Economou—a belated thanks for the encouragement, difficult exercises, helpful critique, and sometimes slashing advice that I didn't always want to hear.

To Jim Chastain—the man, the poet, and the friend. Here's to one hell of a journey we had with words. You are dearly and truly missed, my friend.

To Dorothy Alexander, Carol Hamilton, and Jim Spurr for all the kindness and help you gave Jim and me over the years, as well as your tireless support of poetry in Oklahoma.

To Jerry Bradley and Larry "Buffalo" Thomas—two great Texas poets —for befriending, helping, and encouraging me, in spite of being an Okie.

To Billy and Dodee Crockett—your friendship (and "Poet's Room") there at Blue Rock mean the world to me. Few people have done for the arts what you have done there in the hills of Texas.

Of course, Mom & Dad—you truly have made possible every art endeavor I've ever pursued. Your consistent and unconditional support is the reason any of these projects ever come to fruition.

And, finally, to Ashley, who not only put up with this collection—considering all the poems are about others in my life and past—but also helped edit it like a true professional. Your sharp eyes and durable heart made this book better than it could have been otherwise. You are my salvaged heart.

Contents

Beats per Century..3

Weights and Measures...7

Geographic Eyes ..8

At Café Pink ...9

At Café Plaid...10

Boys and Girls ...11

Three of a Kind ..12

Betting on Blood ...14

Beautiful Corner ...15

In Translation ...16

Damage Control ..17

First Love ...18

First Voyage..19

First Flight ...20

Little Jerusalems ...21

The Priest and the Politician22

Heart Failure...23

0 and 7 ...27

Hats Off...28

Barista ..29

A Poor Reflection..30

All That Is Best..31

Ribs and Stones..32

The Magician's Secret33

After Shocks ...34

Leap Year ...35

My Bean Bag Heart ..36

2 Degrees of Plastic...37

Dunn's Words ...38

Would You Think I Didn't Love You40

Low Budget Analogy..41

And Then She Talked42

All Alike..43

Gypsy Moon ...44

Yesterday—Today...49

Groping for the Switch50

That Friend..51

Already Autumn ..52

Pop & Fizz ...53

Love Dies ..54

Been Down Before...55

In Paris, Maybe ...56

Or . . . Maybe London58

A Way to Go...59

Hollow Classics ...60

Not My Major...61

Piso Mojado..62

That Slight Pain...64

Black Hole ...65

A Shadow of Something...................................66

Would/Could/Would..67

Inside Job...68

Before It Began ...69

Exquisite Pain ...70

Outage ...71

Weathered Man..75

Afterburn...76

Newton's Other Law77

On the Scale of Gods78

Grip..80

Desperado..81

At Half-mast..82

The Pirate Thing ...83

Fare Thee Well ..84

Braids of Paradise ...85

Sideways Love ...86

Ode to Jose Cuervo ..87

Best I Ever Had..88

Mea Culpa ..89

Tracks and Traces ..90

there is much good in being alone
but there is a strange warmth
in not being alone.

—Charles Bukowski

My Sideways Heart

Beats per Century

The ancient Greeks prove
that for thousands of years
the throb and thump of love
have not changed.

The blood-swell
and throat-slit of it all
thrilled and burned
Sappho and Anakreon
in the same ways
they beat up Bukowski
and insisted
that Sharon Olds
be so brutally
and beautifully honest.

Philosophers and engineers
have designed no upgrades
for the heart's technology.

So it beats on,
pulling in and flushing out
blood and dreams—
dreams as primordial
as the alchemy
of the cosmos.

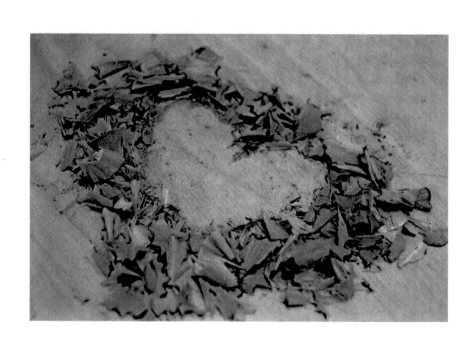

Love shot craps in the morning and,
wagering my soul, lost it.

<div align="right">

–Meleagros
ca. 140–ca. 70 b.c.

</div>

Psalms & lamentations

Weights and Measures

I drop the wet ashes
of that last relationship
on one end of the big,
brass scales.

And now, I carefully place
the sad pearls of loneliness
on the other side

in order for science
to have its say.

Geographic Eyes

Decades now I've been in love
with those armor-piercing green eyes
on the cover of National Geographic,
like the quickening stare that freezes
an Afghan snow leopard the second
it's caught you in the crosshairs.

I wonder what the girl looks like now.
Has she lost that fabulously tattered,
burnt sienna head covering that framed
the bold and questioning torsion
of her upper body in flawless folds?

Maybe her chocolate hair—a frame within
the frame—is beginning to gray like mine.

And I fear politics may have etched
rugged lines into the perfection
of her mocha skin, with the exception
of a barely visible birthmark—or trace
of some past tragedy—that rests
softly on the bridge of her nose.

Those eyebrows—tempered daggers—
slice through prejudice and ignorance
in an unspoken decree, with a dangling
thread of hair down her forehead
as an exclamation point. Lips,
small and red with youth, imprinted
with tiny creek beds not yet eroded by
the grief of a desolate, overly religious land.

Yet, all her features, still pale before
the blazing shadows of those eyes—
those green eyes turned toward me—
that defy my grasp on letters and words.

At Café Pink

He likes me . . .
made my café au lait, no charge
and brought it over to me
with a smile and a wink.

And I think about how
attracted I am to women,
how I love that brief
sweetness—the soft, recessed
shallows in the hipbones.

And I think about how much
I care about souls, want to share
their wine and sadnesses—listen
as their pitchers full of loss
pour poems into my heart.

And I see the scars
in his eyes from the lashes
of an angry, thin-minded
father who couldn't understand
the sound of his son's voice
or the way he walked.

And I want to sit down
with Roger and talk awhile . . .
see if we can tap into a love
of our differences.

At Café Plaid

She pops into Café Plaid—this girl
who lived in the pink brick house
behind and catty-cornered to ours,
back when I still wanted to be Tarzan.

Her bronze skin and white-gray eyes
used to mess with my physiology
before I understood the biology
behind the rush of blood.

Tiny bodies in tiny striped bikinis
light the fire fourteen-year-old boys
must survive to graduate to the next
level of hormonal torment.

When she spread coconut oil
on that skin to make it darker,
my mind would climb acacia trees
and bark like a baboon, and I would
fight the mammalian urge to bring her
the finest nuts and jackalberries.

But today she sports the huge mane
of a male lion attacked with hairspray—
the leopard couture of a junior leaguer.
Her eyes have acquired a savannah silence—
some sort of second language that attests
to a life mid-way through a prescribed,
materialistic regimen of mild torture.

And I want to, but don't—grab her,
throw her in the car, drive out
to the wooded grasslands west of here,
shave her head, and hope for a
return to the relative sanity
and suntan lotion of childhood.

Boys and Girls

Good girls like bad boys
because they know what grows
from the seeds of boredom.

Bad boys like bad girls
because they have no foresight.

Bad girls don't like anybody
because of what happened
in that bedroom long ago.

Good boys think they like
good girls . . .

until they marry one.

Three of a Kind

She broke out the Jacob's Bible Cards
to take me on in strip poker.
Devils were wild and there were three
instead of two—my first clue
that this daughter of heaven
might cheat at cards.

The firelight flickered every time
she splayed out three kings—
often using a devil card
to complete the trinity.
And it happened often enough
for me to believe the Magi
were in search of some new,
aberrant, celestial event.

I held my own for a while, but
it became obvious God was on her side.
And having lost to him so many times,
I dealt myself a crooked hand
just to get her pink top off.

But even in cheating, I could not win—
her long, black hair falling Godiva-like
over her breasts. So, down to my skivvies now,
I threatened: *If I lose, I'm not going
to church with you in the morning*—
such a sad defense for a hopeless sinner.

You promised, she whispered, only one eye
visible through streaming locks of hair.

With that, she spun her wrist around
and spread her final, apocalyptic hand:

three sixes, beating my two sevens.

As I kept the tenth commandment of the game,
she crawled toward me like an angelic cat,
and I melted in the fire of her Armageddon.

Betting on Blood

Every time I open my arms
to try and love again,
I reach in and grab
the new heart I've regrown
since that last loss

and toss it on a color
at the roulette table,
gambling . . . believing—
so close those two—
that someone someday
will stay.

And the wheel turns.
And the ball rolls against the spin
until the pull of gravity
begins the falling.
The ball taps, then bounces,
and eventually drops,
coming up
black
or
red.

And I always bet my heart
on the color of blood.
But the ball has bounced
into the black
so many times now.

Beautiful Corner

She said she'd painted herself
into a beautiful corner—

a corner filled with marimbas,
friends and M*A*S*H reruns.

A beautiful corner that rests
quietly in its lack of testosterone.

And there are some repairs
needed on the shed out back.

But she's happy . . .
she guesses . . .
she says.

In Translation

My hope is like an architect
who glues pieces into a model,
believing his creation will stand, hold,
look beautiful among the storms.

My experience is like the engineer
who turns the model in his hands—
lips scrunched in a frown, head shaking,
never quite explaining why the dream

does not translate into bones
and blood—the materials that create
the manifold space
for a wounded, fragile heart
to beat in, again.

Damage Control

I attract beautiful, damaged women.
Some curse of biology.
Some accident of chemistry. Though,

I don't mean to level blame.
I'm attracted to them too.

And since most everyone
is damaged, the "beautiful"
should be taken as a compliment.

Besides . . . wholesome,
moral, seemingly uninjured
women terrify me. For them,
the concern is basic building materials.

One woman's foundation is
the quicksand of appearances—
the pristine, riparian landscape of denial
that covers an emotional sinkhole.

The other's is a concrete absence
of any residue or grit left over
from having lived an interesting life—
both just separate paths to a living death.

So, I prefer someone who
tosses and turns in the throes
of a childhood desolation,
or some adulthood desecration.

With her . . .
I know where I stand . . .
even if it changes moment to moment.

First Love

You were the purest glimpse
through love's telescope
I was ever going to get.

But I was too young to discern
the cosmic pain in a star's birth
and death—too young to grasp

how atomically hot it burns
every moment in between.
And I could have foreseen

the births and deaths of all my
future loves, if only I'd known
a little more about astronomy.

First Voyage

When it comes to making love—well,
ok, sex—you were my first voyage to Paris,

the "older woman." And I was still too young
to know the cafés, alleys, and graveyards

were much more interesting than
the Eiffel Tower and the Louvre.

You were my impatient mentor—
the Pissarro to my little Monet heart,

filled with restless, impressionistic dreams
of some future, undefined art.

First Flight

You were the fabulous
torch-eyed girl from Canada
that I happened to meet
at the Feast of Tabernacles
in Jerusalem's late summer heat—

one of those stinging moments
in youth when the heart leaps up into
the throat like a frightened child . . .

 . . . this before I'd learned there might be
 advantages to the non-American mind . . .

 . . . this before I'd learned it might not
 get better than a northern siren
 singing at the controls of a Cessna
 while she shows me the turquoise lakes
 of southern British Columbia . . .

 . . . this before I could have known
 we should have made love that night
 in your parents' house—when our jeans
 smoked from the friction of desperation
 but stalled out in all that Christian confusion.

Little Jerusalems

Has all my education,
scrutiny and cynicism,
come to this lamentation?

Oh God, forgive us.
Please grant us healing.
We cry out for peace . . .

not only for the peace
of Jerusalem, but all
the little Jerusalems

of our hearts. Their walls
tumbling down all over
again, crumbling stone

by stone, pushing down
the dead, dusty layers
of past cataclysms.

The Priest and the Politician

The priest builds
an iron cage
around sex,
then sells tickets
for little peeks
in his sermons' illustrations,
multiplying the magnetism
in our groins.

The politician legislates
the proper, biblical uses
of partnership, then pays
for something different
in the dull neon glow
of a motel room.

Heart Failure

The small, stubborn flame
behind my chest bone
finally flickered out
that last time love failed.

And now a loose spiral
of gossamer smoke
snakes its way up
into my skull . . .

the last few drops of wax
now just crimson stains
on the tops of my feet.

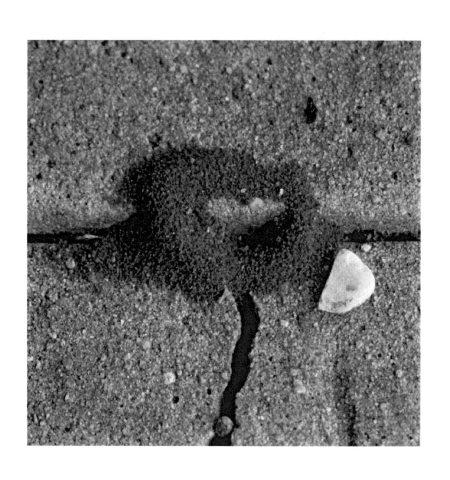

See how Love, like a blacksmith, hammers me,
and then douses me in the chilly water.

–Anakreon
ca. 563–478 b.c

Beginnings, middles,
& in-betweens

0 and 7

For a thing
with no physical form,
love swings a fabulous fist.

And I've never seen where
it comes from—the uppercut
of that blunt power—

that power
 that renders the moon's light a left hook,
 more painful and blinding
 than the sun's

that power
 that holds up this lonely night
 with a broken knife blade
 at my throat.

And it always strikes the face first,
followed by a foot to the gut—

that undisputed champion
of every round we've ever fought.

Hats Off

The women have done me in.
Old mistaken dreams have crawled
so far back inside my body,
I can't flush them out with a stick.

And a couple of these women
will be quite happy to hear
the news—to see my head
here on this cracked platter.

So this is my concession speech.
This is my shameful phone call
from an empty banquet hall,
congratulating the winners.

Barista

Silky hands in jean pockets,
shoes scuffing the floor.

A snake tattoo slithers
down her lower back
to a garden of dreams.

Her eyes radiate like sonar waves,
bouncing back the covert message:
I'm not buyin' whatever you're sellin'.

And, caught in the tractor beam
of her smile, I know her secret.

And she knows that I know
she's a hippie trapped in a marriage
to an ankle-length tweed coat,
expensive ties, and several pairs
of Italian leather shoes.

And every time she brews up my usual,
I want to slip behind the counter,
grab her hand, and make a run for it.

A Poor Reflection

The redbird saw his reflection
looking back from the tinted
back window of my car.

And, seeing some fault—
or the specter of some
other encroaching male—
he attacked his mirrored self
relentlessly all morning,

never quite cracking
the hard shell of his
dark doppelganger.

More proof that whether
feathered, furry, or bipedal,
men are all cut from the same
chaos swirling inside
that bad chromosome.

All That Is Best

I lean down to ask if
she wants another Mudslide.

She turns those fabulous Serbian
cheekbones square to mine—
eyes ablaze in the darkness
and flicker of the tv screen—
and then says, *Are you . . .*
trying to get me drunk?

The faint trace of a complicit
smile attaches to the end
of her question.

And I say, *Absolutely not.*
Absolutely meaning it.

Because now,
at thirty-nine,

I am not going to ruin
the burn in our touch . . .
the electric shock
of a kiss . . .
or the late-spring storm
of a gentle hug from behind,
with quick sex. And because . . .

decades of bad decisions
and nightmares taught me
that the blue flame
is more poetic
than the white.

Ribs and Stones

We walk an older, less traveled
path to the castle of love this time.

Overgrown and hidden to many eyes,
we walk it slowly, hold hands only.

And tonight it took us down
to the edge of the duck pond
in the dark, there by the bridge.

We paused a long time, entangled
in a simple embrace, a cool breeze
rocking the cattails. And finally,
because I couldn't speak it, I held
her cheeks in the prayer of my palms
and bowed my head to the altar of her lips.

The angel-song of silence embraced us.
Her body trembled, maybe from joy . . .
maybe from sensing the demons
that claw at the back of my doubt.

When our lips parted, our foreheads
stayed together, and I found the words:
 Thank you.

And she may have thought
I offered them only
for the kiss.

The Magician's Secret

My heart is well-versed
in the art of escape.

I've used trap doors,
smoke bombs, and
shifting mirrors . . .

freed myself from the stakes
that one girl soaked in gasoline—
untying the knots as she lit the match . . .

slipped out of chains and locks
in a glass tank that another one
slowly filled with water.

and here I am now, with you,
making plans . . .
loading up sleeves . . .
stuffing rabbits into hats
and fake flowers into wands.

But I've forgotten the magic
words, the incantations.

You seal my lips with yours
before I can utter the spells.
You stay my arms
before I can wave them.

And you step right through
every silver cloud
I explode between us.

After Shocks

In the heart of the flatlands,
an early summer thunderstorm
rolled through at three a.m.

Lying next to me, Ana—
a growing portion
of my heart—
began to whimper in her sleep.

She backed into me
until awaking
with a quiet scream,

then she wrapped around me
like a frog on a fingertip.
I asked what was wrong.

She said the thunder sounded
like the American bombs
that rained from American planes
leveling the city of her birth
in former Yugoslavia.

And she held me as if
to prove to an American
that she was beautiful and
filled with love, and that

she could rebuild her home . . .
maybe even stop the pounding
of bad dreams at night.

Leap Year

It was just a kiss
early in a balmy autumn
early in my teenaged life.

But the girl—older, golden-
skinned and honey blond,
a fresh blossom of Texas—

floated alongside me
like a wind-blown dandelion seed
in a warm September breeze.

Midway through our walk
in the woods—paused on a bridge
over a blood-red creek in flood—

she trapped me against the rail
and darted in, rolling her lips
over, through, and inside mine.

And though it went no further,
I somehow knew it was time
to learn to write poems.

My Bean Bag Heart

My heart's a big, red
bean bag chair . . .

just molds to whoever's
sittin' on it.

2 Degrees of Plastic

Flat broke. Both of them.
He smiles at the slurping drain
at the bottom of their bank accounts.

> And he remembers how well poverty
> had worked in the first half
> of his only marriage, and how
> that first job and influx of capital
> had lit a fire in the wife's eyes.
> She developed a taste for VISA,
> wanted more, and a year later
> had the papers drawn up—
> because she'd found more
> somewhere else. The child
> would be fine, and custody
> would be hers, of course. And he
> adjusted to the amputated life,
> sent half of every paycheck.

He's now in a different world
with this broke, different girl.

And on his way to see her at work,
he buys a red plastic heart
filled with Skittles—$1.63.
He slips it to her when they embrace.
She gasps, cries, hugs him
tighter, pets the little plastic
heart, then gives him a kiss.

Dunn's Words

I guess I hadn't realized how long
it'd been since I'd stayed out talking
to a beautiful girl in a quiet bar
right up to closing time.

To be honest,
I guess I didn't realize
that I hadn't actually
ever . . . done that.

But she was fantastic with her big
generous scoops of honesty about men,
women, blow jobs, and the failure of
monogamy as a mode of relationship.

She laughed coolly, bitched loudly in her
thin glasses and the overall bra-lessness
of a Kansas-girl-gone-Manhattan.

And why did I sing *Hell yeah, sister!*
when this now New York chick
railed against men thinking
with their dicks, against men being
generally cheats and pricks?

Maybe because I could tell,
by the way she put her foot
on my stool, that she still loved us . . .
just wanted us to straighten up.

Maybe because I can't stand men either . . .
wouldn't want to live with one myself—
pissin' on toilet seats and throwin'
dirty socks and boxers on the floor.

Maybe it was because a few men still
want a girl to give them the chance
to be—in Stephen Dunn's words—
the best disappointment she's ever had.

Would You Think I Didn't Love You

if I admitted to my uncertainty
that there are any stars left in the heavens . . .
that the only thing we see now is a trail
of light raining from a cloud
of cosmos long dissipated?

 . . . or . . .

if I told you I've seen angels crashing
in the streets and yards all around us
in a downpour of failed attempts to answer
the prayers of too many broken hearts?

Low Budget Analogy

He called Barb from a coffee shop
in the city, but she yawned into the phone
half-formed words about kids, a school
project, and the ex getting weird again.

He tried Penny when he got back to town,
but her number didn't work anymore, as if
she'd left a special message just for him.
Fairly effective he thought, after five tries.

He only thought about ringing Ilene.
Her email responses seemed curt lately,
like quick amputations of sentences
that no longer contained a point anyway.

And now his house felt like the set
of a low budget movie where something
that could never really happen has happened
after all, and Charlton Heston finds himself
on the hissing shore of some apish planet,
desperately searching for some remnant
of a lost civilization, defeated and demolished
by its own fear and greed.

And that analogy went a few steps
too far in its effort to fill eight lines.
But it sings true, nonetheless.
Because he does feel pretty damn lonely.

And Then She Talked

He shrugged his shoulders
over and over as he told me:

"She wouldn't have been too bad
if she hadn't rattled on incessantly
like republicans on AM talk radio . . .

Actually, she would have been
quite ravishing without the nasal
disapproval of the pan-seared tuna . . .

To be honest, she would have been
the most beautiful woman I've ever
seen . . . if she hadn't said a word."

All Alike

So . . .

 Are we ever going to kiss?

the beautiful girl asks me tonight
as I pull up in front of her house
to let her out.

And so . . .

here I sit, behind the wheel,
the typical American bastard male
who's only out for one thing—

that one thing that's always on
a male's mind . . . the only thing
we think or care about . . .
ever . . .

 And I'm shocked
 she's in such a big damn hurry.

Gypsy Moon

The moon is a sunburned banjo
floating behind the cypress
in the bayou mist.

And somewhere
your gypsy soul is dancing
beneath its waning, yellow light.

I'm lost in these watery woods—
this cemetery with no granite
marking the graves.

And though there's a small boat
beside me, I can't find the paddle.

So I lie on my back, in the palm
of a decaying dock,
and stare up into a strangle
of pitch black silhouettes—
the forest folding its hands
over the soft chest
of southern Louisiana.

And here, in this Stygian now,
it is enough
that the white-fingered clouds
are plucking the strings
of this sky-borne banjo . . .

and it is enough
that somewhere
you are dancing.

Yesterday—Today

A manic need for motion
moves me from town to town.

A wishy-washy love weevil
braids a thread of distrust
in my heart that pulls me away
from the last place I met a girl
I thought I'd like to get to know.

Yesterday—dinner in Dallas.
Today—lunch in Austin.

I live under no illusions
as to my mental health here
in the coffee offices where I hold
these absurd self-therapy sessions.

And alone now at the Spider House,
with hippies and their organic brew,

all the warped and broken furniture
gives me a metaphor to hang
my emotions from.

Groping for the Switch

I want only to continue
wanting that first kiss . . .
to always stand a foot away
from all that it destroys.

I want to dream inside
my dreams of making love
to you . . . waking just before
the meltdown and fallout.

And I can't find the breaker
tripped by that last loss . . .
leaving me here—falling
in love only with the falling.

That Friend

She calls me up
between boyfriends—
relieved I'm still
not seeing anyone.

I'm a good diversion,
and besides, it's not like
I've got anything to do.

So we hang out . . . talk
on couches and floors . . . listen
to Willis Alan Ramsey, until,
mid-sip of some cabernet,
her phone rings.

At that point I know
it'll be a few months
before we talk again.

Already Autumn

We knew it would end
 the moment
it began last spring.

But now it's already autumn
 in your eyes
and you want to let go early.

You're afraid you will
 hurt me.
But I felt that pain in our

first kiss. There on the bridge
 that night,
I knew not to do this.

And I knew that
 was exactly
why I would do it anyway.

And I see you behind this
 heavy gate
that blocks the way to your heart.

And I can't get to it for
 the one
that blocks the way from mine.

But you have taught me to say
 the word
love in a language I didn't know

existed before the day we met.
 And that . . .
I could not have missed.

Pop & Fizz

In the backyard, we shot
the champagne cork
over the fence. It was dark.
We had no idea which neighbor's roof
took the blow. We laughed
and ran inside to toast
something. I don't remember
what. We were always toasting
something.

You like the fizzy blood
of that cheap red Ballatore.

And both our lives
had been filled
with that color.

 And that is why,
I will remember our brief season
as something beautiful—something
much like the explosion of that cork
up and over the fence,
disappearing
into a shatter
of stars.

Love Dies

so many different deaths.

Sometimes it burns out
in a long fermata of failed—
and a few too many—words.

Sometimes it crescendos to a loud,
dissonant, and final chord of screams
in a wasteland of minor thirds.

On those rare days, though,
it rides out in a positive,
smiling turnaround
at the end of a sweet,
sorrowful song—
one that loops
over and over
until it finally
fades out.

Been Down Before

This time the bottom—
the basement of love—
feels almost comical.

Been down here enough
to know where the switches,
the couches and towels are.

So I just fluff the pillows,
shake out the blankets . . .
try to make myself comfy.

In Paris, Maybe

It's a silly thought—a little picture
that keeps coming to mind—
of a time when we meet again.

We're in Paris. Autumn falls wet
outside a small Latin Quarter café.
The sun is almost gone. The soft swell
of an accordion drifts across the avenue.

Dobro veče, I remember to say. Your eyes
smile from under one of your fabulous hats.
I kiss you on the cheek and put my hand
on the back of your arm as we step inside.

You shiver when we sit down,
and I offer you my coat, knowing
how cold you always get.

How's Sierra? you ask in a much
heavier accent now. I roll my eyes.

She's thirteen, and the boys are givin' me hell.
You laugh as I hand you a picture.
You cup it in your hands and gasp—
a tear slips out the corner of your eye.

We talk over a coffee & sugar for you,
a coffee & cream for me, about her,
our time together, the new people
in our lives now. And I can't not say
You're as beautiful as ever. And one time
our hands touch by the candle
on the table before we get up to go.
And we hesitate in each other's eyes.

Finally, after a fight over the check,
we step out on the sidewalk in the glow
of sodium lamps and don't know how
to say goodbye, but eventually part.

After five steps, I shiver when I hear:
Nathan! I spin and you're walking back
with my coat. I take it with a *Thanks.*
And that's when you reach up on the tips
of your toes and kiss me on the cheek,
very near the lips, and then turn quickly
to go, hiding your face. And I whisper,
Çiao, ljubavi, but I'm not sure you hear me.

And that's when, in the echo of our footsteps,
I know that not a single minute of your last
year in America was wasted.

Or . . . Maybe London

She loved the poem I wrote for her—
"In Paris, Maybe." She cried, actually.

And like I said, she really liked it, only . . .
she wanted us to meet in London, maybe.

And she didn't want us to have other
people in our lives. And I decided at this point

I'd need to change the accordion music
to something more English, maybe.

The weather would be similar in autumn.
No problem there. But the main thing

she worried about was the ending where,
after we part, she shouts my name and I spin,

but it's only because she'd borrowed my coat
and needed to give it back. That . . .

that would not do. She wanted that changed
to an embrace, filled with tears and a promise.

A Way to Go

I want her last impression of me
to be carved out of the night—
 something about streetlights
 and the moon fingered by clouds.

I want her to remember me
in the amber glow of cantina lamps—
 something about the smell of lime
 and salt on our fingertips and lips.

I want her to recall my silhouette
in the window of a closed bakery—
 something about the fragrance
 of an evening's mist on the sidewalk.

I want her last sensation to be
my hand on the small of her back—
 something about steps and doors
 and decisions not to kiss . . .

Hollow Classics

Huge, gold-leafed editions
of *War and Peace* and
Tess of the Durbervilles—

two hefty classics—lie
on their backs atop
her glass coffee table.

Only . . . they are hollow,
made of wood, with hinges
so the front covers lift up.

She neatly stores
all the remote controls
there inside them.

And some metaphors
are just the simple gifts
they appear to be—

the way I see her now . . .
and all those years
we spent together.

Not My Major

After our talk last night
on your front porch,
I started putting 2 and 2
together.

And when I got to 39,
I figured it was over
between us.

I failed you somehow—
just like algebra in college.

Piso Mojado

I'm fighting with a beautiful woman.
So I go alone to a local steakhouse
that I cannot at all afford.

She says I'm a waste of her time.
She's probably right. So,
I order the Perfect Margarita

and raise a toast to a TV screen,
offering one to her, and one
to the Winter Olympians

skiing the Super G in tights.
I wonder where she is while
I order the Hawaiian Sirloin

with garlic mashed potatoes.
And—waiting on the meat—
I read my friend's new book

on Charles Bukowski and think,
Maybe I don't objectify women enough.
But, that's the margarita talkin'.

Yet, at the same time,
I like the way it thinks. See . . .
I don't believe women can stand

a sensitive man in the light of noon.
They just wanna read about 'em
and watch 'em on the big screen.

In person they want what they
expect. Otherwise, there's nothin'
to bitch about to their friends.

And this is all crap, of course.
And this margarita's buzzin' me
like the warmth of her hand would.

And I slipped on snow and ice
all day today without her.

That Slight Pain

I thought I might write my way
back into your life—poets feed
on delusions like this. (Though,
we prefer to call them dreams.)

But you're a peak worth the climb.

And if I fail—if I fall
from one of your overhangs—
I hope I reincarnate as a crow
that flutters in your mountain path
and bothers you on morning walks.

Or maybe I'll resurrect
as the Man in the Moon
you love so much, and my face
up there will bug you to no end
as I light your late night strolls.

In short, I long to be
that slight pain in your ass
that makes you smile
and grimace all at once . . .
occasionally driving you
to reach around and tug
at the back of your pants.

Black Hole

An interminable pile of papers
 wait to be graded
 there on the floor.

A neighbor backed into my truck today,
 smashing the driver's side
 into modern art.

A hernia just poked its little nose
 outta my business, and I
 have no health insurance.

A bullet tore a tunnel through my brain
 last night when a woman
 I'd slowly fallen in love with
 quickly fell out.

And they say the light and heat
 is beyond imagination
 when an old star finally
 releases its grip on gravity.

A Shadow of Something

Your gentle rejection of me
under a waning harvest moon
was a searing explosion of light
that ran, clean, through my skin.

It burned a shadow of something
left inside me onto the back
of the bench where we sat.

I ran my hand over the charred space
and rubbed the ashes between my fingers . . .
smelled them like a confused anthropologist,
then wiped their blackness onto my tongue.

I wanted to eat that darkness . . .
to taste that shadow . . .
preserve the negative . . .

so I can try to print
a picture
of what is left.

Would/Could/Would

Now that I've stepped out
the other side of this thing,
I can hold that conversation
with myself that I would have
with you, if we were still talking.

I don't want to be tied to anything.
I like it when the phone doesn't ring.

I do wish, though, one time—
when you still wanted it—
I'd grabbed the back of your neck
and pulled you in for a kiss.

I wish our clothes had flown
off onto the shelves and floor
at least a few times.

I wish I could have washed
that amazing hair, at least once.

And, yes, I poked around
for reasons to end it too . . .
my head already rolling
down some state highway
towards a better poem
or picture. But . . .

I wish we would have done more
with that wonderful little we had.

Inside Job

There on the Pont des Arts
bridge over the river Seine,
it rained the entire day
after you'd taken down

all the da Vinci's and Monet's—
 the Mona Lisa's and lilies
 of my dreams and desires—
from the walls of my brain

and slipped away with them
into the foggy shadows
of that night in Paris.

Before It Began

When we met,
I knew all the reasons
you would leave.

I've run the experiment
with the necessary controls
quite a few times now.

So . . . I came to the party
with amputated expectations.

> And I'm sure you'd prefer something
> with a nice sunset and a good horse
> here at the end of things.

Anyway . . .

I could have listed them for you,
but I think I'll keep them secret
for now . . . since I want the chance

to have things not work out
again
with someone new.

Exquisite Pain

A scatter-bomb of beautiful women
exploded in the backyard of my life
not too long ago. It bears all the marks

of a cosmic joke. The Muses love
to pull little strings in heaven's
humor department and torture me.

They know I thrive on the exquisite pain.
And these beautiful women abound.
And these beautiful women talk to me

now. Laugh. Even go out with me
sometimes. And I think it's because
they can smell that I don't trust them . . .

or . . . necessarily . . .
find them attractive
anymore.

Outage

When you walked away,

you threw a switch that sparked
right before the dull flash
that brought it all down
to a dead-still darkness . . .

the switch that once
sent current to the bulbs
that lit the dripping chambers
of my grieving heart.

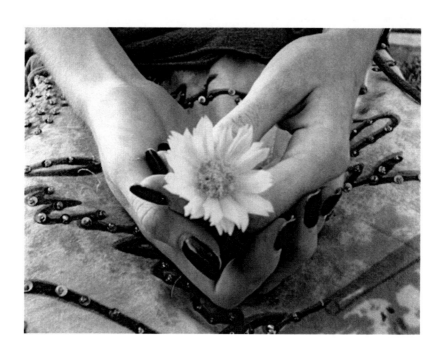

With the second drink, at the restaurant,
holding hands on the bare table,
we are at it again, renewing our promise
to kill each other.

—Sharon Olds

Pirates have feelings, too

Weathered Man

She was a Phantom of delight
When first she gleamed upon my sight;
 —Wordsworth

Her maiden beauty came on
like a quiet but threatening storm.
And I've weathered many on the sea
of these waving Oklahoma plains.

But a green phantom swirls
in her center, and if she turns
my way, she'll wipe me out
like a trailer park in spring.

Some combinations of torso and limbs . . .
hair and eyes . . . come together
like hot and cold fronts colliding
on the edge of the jet stream.

They are the stuff of myth—
as cruel as they are beautiful . . .
proof that God is a prankster.

So, I turn a sailor's eye
to the liquid horizon . . .
check the clouds for color.

Afterburn

I just sucked coffee
down the wrong pipe—
almost coughed it out my nose—
all for the passing thought of somehow
landing again in an exclusive, long-
term relationship with the superior sex.

She's always so beautiful at first,
and I always imagine that moment
when the tip of my finger touches
the damp heat in her palm.

I dream of the arching flame
that would flash between us
when my teeth lightly pinch
her lower lip, and how our hearts
would then beat to the rhythm
of skin drums in the torch-glow
of an African night, right before
I take her on the shores
of any number of fictional islands.

Every flash of an eye, toss
of gold hair, or pulse in the vein
of a fabulously sexy forearm,
goes off in the back of my skull
like the explosion that launches
the death of throbbing stars.

And all this in the half-life of a clock's
tick, before I zap back and remember
what happens when those stars
fade to black.

Newton's Other Law

A sea-side bench here
on the beach along the bay—
a good day's drive from her—

gives me time to contemplate
the inertia of who I am
when in motion

and the laws that state
my tendency to stay exactly that
unless acted upon by some new,
blond and stunning external force.

On the Scale of Gods

We've stood in the same room . . .
talked . . . shared drinks once
at that campus party thrown
by the Department of Narcissism—
a veritable Pandora's Box
of academic Nymphs and Titans.

But soon we will sit, just the two of us
at a candle-lit table in the Siren shadows
of the Parthenon, and share drinks again,
but this time with more attention given
to the Athens in your eyes.

And fearing my Achilles' mouth—
my Nemesis—I'll not say many things
as I press my hand to my lips, trying
mostly to listen, because, if I speak,
a thunderbolt might slip out, like . . .

you are the most beautifully intricate
Muse I have ever seen—mermaid eyes
the size of lemons but the color of water
curving into a white sand lagoon—
hair, a thick bed of Dionysian curls
that spread out like the daughters of Poseidon
in a sea storm—bronze skin yet unsullied
by the sotted minds and fingers of sailors—
and lips that made me—a meek Orpheus—
put down the pen of Apollo just now
and wonder if I should even continue,
because . . . I will want to kiss you.

I will want to lean across that table,
steady your uncertain hand,
and press on into the most fabulous
set of Greek sails I would ever raise.

I'll want you to push toward me too
with the fiery-red flush of Eros
across your face like Aphrodite
under the spell of Adonis—
knowing you shouldn't do it.

And in that moment, the sun . . . even
Zeus himself . . . would stand still
over the Aegean Sea
and we would burn down
the Elysian Fields
right there
under the eyes
of Olympus.

Grip

She's visually stunning,
in an un-American way.

I've caught men in the act . . .
actually heard their necks crack
as they twist for a second look.

And I'd forgotten how much energy
it takes to love a girl like this—
how it requires you to reach down

and grab yourself by the jockstrap
with a yank, tighten your spurs,
then pop your knuckles.

And it's why these relationships
can't last. A man gets tired.

But while you're in it? Whoa boy . . .
it is the National Finals Rodeo
of Love, my friend.

And it's why, to anyone
who's ever ridden in the event,
eight seconds seems like an eternity.

Desperado

The ability to disappear . . .
to—on a dime's-drop—
be on my way to somewhere
where no one knows where I am . . .

this is how I've protected myself
from madness's relentless insurgency
against the burning Rome of my mind.

Some of my better relationships have been
with waitresses in restaurants I never return to.
Yet, if the chemistry's great, I might
return once or twice just to prove
I can be monogamous.

I went madly in love for a week
in Switzerland once; two weeks
in Hawaii; a whole month
in Israel. That one hurt.

And I'll never forget floating above
the Atlantic next to the gray-eyed
Latvian girl on a flight to Moscow . . .
the plans for me to visit.

It's only when I live in the same town
as a beautiful new blue-eyed problem,
that I lose my grip on the pen.

That's when the raking of saws
and pistol shots of hammers
keep me awake at night—

the noises of a crew of cupids
building gallows in the distance.

At Half-mast

You'll go back to him.

Your eyes screamed it
like a North Atlantic squall
as I read between their red lines.

With your third amaretto sour
at half-mast, you finally slipped
out of *cool-and-collected* and into
this-is-worse-than-I've-been-letting-on.

And it hurt to watch that ship capsize
in the tempestuous sea of your heart . . .

but it killed me to abandon
the flooded decks of the one
sinking down deep into
the bloody waters
of my own.

The Pirate Thing

Besides,
it's better this way.
I mean . . . c'mon . . .
I'm basically a pirate
who tries to be a little more
like Gandhi every day, but . . .
the pirate thing . . . you know—
the boots, the sword, the hat—
keeps gettin' in the way.

I slip down gray sea-lanes
of ground stone, often
for months at a time, sloshing
from port to port, whipping out
my effects—poems, pictures,
and the occasional ballad.
And we both know . . .

no one deserves to haunt
the bone-dry, land-locked end
of a swashbuckle-dream like that.

Fare Thee Well

Should you decide that it
should be he, instead of me,
I shall accept the notification
sent from your firm boot
kicking my fairly firm ass,

and I'll slap on my tricorn hat,
throw my shoulders way back,
and hoist the sails with a hearty farewell.

But through your days there
at your cubicled computer,
or sipping on a pale ale
in a land-locked bar somewhere,
remember this: somewhere . . .

out there . . . sailing the American Sea . . .
is a tequila-swigging pirate-poet
who just might pull his swaggering,
sodden ship back into port
if you ever need some company.

Braids of Paradise

Late on Thursday nights sometimes—
when she's working—she brings
a glass of the house white zin,
her hand brushing my shoulder.

A nest of black braids sizzles
when she turns to walk away.

They fall like the frayed end
of a long and scorched rope
she's lowering to save me
from the dark, dank pit
of my restless mind.

Sideways Love

In the island town of Kapsali,
who needs the trap of commitment
when he can eat the Venetian Crepe
with a glass of red at Banilia Café?

The bleach-blond Madame—riding
the crest of her fifties quite well—
sweeps out with a tray and a smile,
singing "bon jour" and "kalimera"
in a single bilingual breath.

I grab my chest and whisper "merci."
She caresses my shoulder and laughs
in French . . . and all is well.

And life is full of sideways love . . .
and there are so many kinds . . .
so many options that don't require
flowers and a phone call every hour.

Ode to Jose Cuervo

A House Margarita
at a dark corner table
just before closing time,

> is like dancing at the junior prom
> with the hidden beauty of the girl
> wearing glasses and thick braces.

A House Margarita
and a yellow corn tortilla
after a gray day's work,

> are the wine and bread . . .
> communion . . . at the end
> of a cold, wet trail.

A House Margarita is kind,
enjoys the cheap date
and laughs at your jokes.

> And sure, I swig the expensive stuff
> now and then—I've dropped
> twenty bucks for the Baile del Sol
> at Maria's in Santa Fe.

But a House Margarita . . .
she's the good woman
you know you should marry.

Best I Ever Had

Margarita,

we've been found out. They know
we're seeing each other now.

Some register concern, worry
things are getting too serious.

But, my love, you came to me
during the darkest day . . . an icy hour,
when ruin fermented my heart.

You are sweet, yet salty,
and swollen with the nectar
of the blue agave gods.

The juices of oranges and limes
flood your shores . . . and oh . . .

the way you make me feel
after a night drenched in passion.

Mea Culpa

Most of the women I've loved
saw a therapist on a regular basis.

(Only one refused to . . .
and she was crazier than shit.)

And let's face it, men . . .

 we put them there.

If not us, then some mother
who'd been screwed up
by one of us.

And we're just gonna have to
pay the price for that

as long as they feel like
ringin' up the register.

Tracks and Traces

What could bring me back
to the towns of love?
A beautiful face?
Nice legs, a great chest?

Too late for all that.
Been to the end of those trails.

Besides, I'm an arms guy.
And necks tell more . . .
make me shift in my seat.

I fell for the accent once.
The only difference there?
I paid for it in Euros.

And so this bloody trail
of heart-pieces behind me
leads to this warped and weathered
train station in the outbacks of love.

I sit on the platform's one broken bench
and watch the few trains—that venture
out this far—roll in . . . and roll out.
I dream about boarding one
or the other . . . wonder if people
still live in houses together
down in the suburbs of normalcy
where these tracks shine
from heavier traffic.

But every time I take a deep drag
of this vast ocean of clean air,
I lean back on the bench . . .
decide to think about it . . .
a little more.

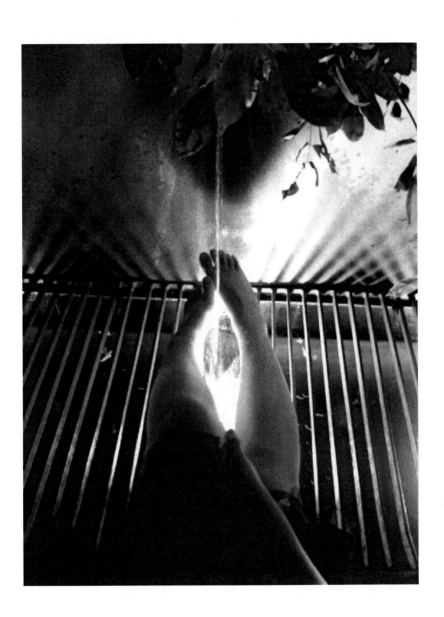

Nathan Brown is a poet, musician, and photographer from Norman, Oklahoma. He holds an interdisciplinary Ph.D. in Creative and Professional Writing from the University of Oklahoma and teaches writing there as well. But mostly he travels, performing readings and concerts as well as speaking and leading workshops in high schools, universities, and community organizations on creativity, creative writing, and the need for readers to not give up on poetry.

He has published five books: *Two Tables Over* (2008)—winner of the 2009 Oklahoma Book Award, *Nôt Exǎctly Jōb* (2007)—a finalist for the 2008 Oklahoma Book Award, *Ashes Over the Southwest* (2005), *Suffer the Little Voices* (2005)—a finalist for the 2006 Oklahoma Book Award, and *Hobson's Choice* (2002).

Released in the fall 2009, Nathan's new album, *Gypsy Moon*, is his first musical project to be produced in more than a decade.

His poems have recently appeared in: *World Literature Today*; *Concho River Review*; *Blood and Thunder*; *Wichita Falls Literature and Art Review*; "Walt's Corner" of *The Long-Islander* newspaper (a column started by Whitman in 1838); *Blue Rock Review*; *Windhover*; *Oklahoma Today Magazine*; *Byline Magazine*; *Christian Ethics Today*; *Crosstimbers*; and *Poetrybay.com*, and in the China-US anthology: *Two Southwests* (Virtual Artists Collective).

For more information and to contact Nathan, visit his web site: www.brownlines.com

CPSIA information can be obtained at www.ICGtesting.com
Printed in the USA
LVOW010133160112

263998LV00003B/62/P